Tomasz Z. Margol

In Christ

London 2018

© Tomasz Z. Margol

Cover Image: Face of Christ Pantocrator, fresco, circa 1250 by Jacopo Torriti

Introduction

Paul's letters are the first chronicles of the life of the first Christian communities. They are also mines filled with theological knowledge, though their main aim is to encourage the faithful to live in holiness (1Thess 3.11-13). The expression "in Christ" (Gk ἐν Χριστῷ) seems to represent Paul's relationship towards the Lord, the Christ.[1] Examining its meaning seems crucial for the accurate interpretation of Paul's authentic writings.

I myself find this expression very important in my Christian life. The whole reality of

[1] Constantine R. Campbell. *Paul and Union with Christ. An Exegetical and Theological Study* 67.

our existence makes sense only because of God, who desires us. He seeks to abide among us, just as he did among the people he chose as his own (1Kgs 8.10-12). With the incarnation everything changed completely. In Jesus ("Immanuel" Is 7.14, Mt 1.23), God became present amongst us and continues to be present here and now. I am strongly convinced that Paul experienced this in a very profound and personal way - in his "revelation of Jesus Christ" (Gal. 1.12) and in his subsequent ministry. Paul shares this living experience with us, because we are all called to this tremendous intimacy with God, here on earth for a while in an imperfect manner, and then fully in the eschaton.

In this paper, I would like to investigate Paul's use of the term "in Christ" with special reference to Galatians 3.26-29. I will approach the subject from a theological perspective because I am convinced that Paul can be understood

only as one who experienced God's work in his life in a profound way. I am convinced that his very encounter with God was for him a reality, and his apostleship is a response to this and the need to fulfil God's will. In order to remain faithful to Paul's original thinking, I will focus on the undisputed seven letters.[2]

In the first section, I will consider the expression, "in Christ" in a general overview of the undisputed letters. Following this, I will make an exegetical study of Galatians 3.26-29, in which the phrase is prominent. This study will prompt examination of the various interpretations of the phrase which have been put forward in the past. I will set out two main ideas: first is the interpretation of "in Christ" indicating a mystical, personal

[2] About authenticity of the Letter to Colossians and Ephesians. Ben Witherington III. *The Letters to Philemon, the Colossians and to Ephesians. A Socio-rhetorical Commentary on the Captivity Epistles* 1, 99-100.

experience in which the idea of 'incorporation' suggests the sharing of an intimate relationship with God, separated from everyday reality and leading to "becoming Christ", that is, in some way entering the mystery of Christ. Second is an alternative 'ecclesial' interpretation which emphasises participation "in Christ" as a feature of the Christian community, a necessary consequence of its identity as "the body of Christ" (1Cor.12.27). In this interpretation any idea of lofty mysticism is dismissed.

Subsequently, I will analyse and reflect on these two approaches. I recognise the importance of both ideas, that is, 'incorporation' and 'participation', and aim to highlight the significant elements of each one, while acknowledging the insights of recent studies. The conclusion to the whole discussion will follow.

Section 1

The phrase ἐν Χριστῷ - "In Christ" in Paul's undisputed letters

Paul's undisputed letters contain 61 instances of the expression "In Christ"[3] - ἐν Χριστῷ.[4] This expression, as Dunn points out,[5] is a distinctive feature of the Pauline letters, occurring elsewhere in the NT only in 1 Peter (3.16; 5.10,14). Investigation of its use by Paul reveals that he uses it in a great variety of

[3] James D. G. Dunn. *The Theology of Paul the Apostle* 396.
[4] 4 occurrences in 1Thess, 7 in Gal, 12 in 1Cor, 7 in 2Cor, 3 in Phlm, 10 in Phil, 13 in Romans.
[5] Dunn 396.

contexts and applies it in particular ways. I will present examples from the undisputed letters which illustrate this.

In his first letter to the Thessalonians Paul writes to the community which is "in God the Father and the Lord Jesus Christ" (1Thess 1.1). In this way he confirms the identity of the believers as belonging to God and to Christ. Paul then goes on to affirm and encourage them with reminders that they are "beloved by God" and "chosen" (1.4) and that they had emulated "the churches of God in Christ Jesus that are in Judea" (2.14). This phrase is repeated in Gal 1.22, suggesting that it was a way in which early Christians identified themselves. Having thus pointed to the Thessalonians' new status "in Christ", Paul moves to settle the anxieties which have arisen with the death of some believers and the concern that they will be absent when Christ comes. Paul gives them the assurance that "the Lord himself... will descend from heaven and

the dead in Christ will rise first" (4.16). The community can easily follow that here; "in Christ" signifies those who died as believers. The "dead in Christ" are those who belong to Christ through their faith in the gospel. In the same letter Paul writes: "for this is the will of God in Christ Jesus for you" (5.18). This time the "in Christ" formula points to the salvific act of Christ willed by God for believers. Earlier Paul has reminded these believers of their salvation through "our Lord Jesus Christ, who died for us, so that whether we are awake or asleep we may live with him" (5.9-10).

In the First Letter to the Corinthians Paul's address is "to the church of God.... to those who are sanctified in Christ Jesus" (1Cor 1.2). Sanctification or holiness is an attribute of God, who has made it possible for believers to enter into holiness by calling them "into the fellowship of his Son, Jesus Christ our Lord." (1.9). This 'fellowship' (Gk κοινωνίαν) signifies not

merely a 'sharing' in the things of God, but conveys divine ownership as Paul confirms: - "you belong to Christ and Christ belongs to God" (2.23). The Apostle uses the phrase "sanctified in Christ" to emphasise the future status of those who belong to the family of believers. All that they have received comes from a relationship with Christ. They are sanctified by God in Jesus.

In the same letter, Paul tells how he became the father of the community "in Christ Jesus" (4.15). Paul's understanding of this role has developed in the course of his preaching the gospel and founding communities of believers who continue to look to Paul for guidance. In reminding believers that he exercises his role "in Christ Jesus", and in sending Timothy to remind them of "his ways in Christ Jesus" (4.17). Paul is constantly making the Corinthians aware that he and they are acting out their lives in ways that are distinctive from the pagan society around

them. In exercising his fatherly role "in Christ Jesus" and caring for the Churches, Paul is motivated solely by his own commitment to living in Christ (1Cor 15.22).

In 2 Corinthians, Paul writes "it is God who establishes us with you in Christ" (1.21) and then, a little later, "in Christ we speak" (2Cor 2.17). Paul here proclaims the authenticity of his mission and preaching. This is necessary since his position has been seriously undermined in the community, in part by the arrival of other missionaries, the 'super-apostles' (2Cor 11.5), and perhaps by factions opposed to Paul within the community itself. Paul must therefore continually assert the truth of his gospel and point out that only with the coming of Christ, comes the possibility of true freedom and transformation, as the veil, blocking the mind of the people of Israel, as it once blocked their sight of Moses, (Ex 34.33ff), need do so no longer - "only in Christ it is set aside" (3.14). Paul

can then go on to say: "So, if anyone is in Christ he is a new creation…" (5.17). Transformation of human kind has become possible and this is wholly through God's action in Christ, for "in Christ God was reconciling the world to himself" (5.19).

Paul writes to the Philippians from prison, where he is being held on a capital charge. Strangely, he is full of joy. As Hooker points out, "The Letter expresses confidence about Paul's own future since, whether he lives or dies, Christ is with him".[6] Paul is concerned about his friends in Philippi. The community is suffering from the presence of opponents (1.28) and from divisions among its members. Paul pleads for unity based on their new identity "in Christ" (Phil 1.1) and urges, "Let the same mind be in you that was in Christ" (Phil 2.5). Christ must be the inspiration for the communities. He is not

[6] Morna Hooker, "Philippians" 105.

only their Lord, but also the source and the example of proper thinking, speech and conduct. In ending the Epistle, Paul sends greeting to "every saint in Christ Jesus" (4.21). The meaning of "in Christ" here echoes that in 1Thess 2.14 where Paul refers to all the baptised.

To Philemon Paul writes, from prison, "though I am bold enough in Christ to command you…yet I would rather appeal to you on the basis of love" (Phlm 8-9). On the one hand the apostle is indicating his authority to command obedience among the faithful, but on the other he is conscious of the love that must bind together the community of Christ. Yet this authority is not Paul's own, since he is "a prisoner of Christ Jesus" (verse 1) and does whatever Christ wills. Paul then asks Philemon to "refresh my heart in Christ" (verse 20). This time "in Christ" signals that it is not Paul human's desire which must be satisfied, but his desire to see and do everything for Christ.

Paul's Letter to the Romans contains 13 instances of the term, "in Christ (3.24; 6.11,23; 8.1-2,39; 9.1; 12.5; 15.17; 16.3,7,9,10). The first has significance in Paul's summary of God's action for all believers, namely that "they are now justified by his grace as a gift, through the redemption that is in Christ Jesus" (3.24). As he develops his argument, Paul specifies what this 'redemption' means for believers. Being baptised into Christ Jesus they are baptised into his death.[7] As Christ was raised, so too believers are raised (from sin) and "might walk in newness of life" (6.3-4). They are dead to sin and alive to God in Christ Jesus" (6.11). Later Paul writes "there is therefore now no condemnation for those who are in Christ Jesus" (8.1) and points to the freedom from the law of sin which results from "life in Christ" (Rom 8.2). Both uses of the expression mark the new situation of those who believe in Christ.

[7] Cf Rom 6.3-6.

In his closing address, Paul sends greetings to a number of believers who have been active in spreading the gospel. Prisca and Aquila, and similarly, Urbanus, work with Paul 'in Christ' (16.3,9). Of Andronicus and Junia, identified as 'apostles', the apostle writes: "they were in Christ before I was" (16.7), as if the term 'in Christ' conveys both their acceptance of the gospel and their missionary activity. Appelles is "approved in Christ" (16:10). The term thus appears to point to the identity which all believers claim as their new reality, specifying that Christ is the centre of everything.

Section 2

Galatians 3.26-29

A general survey of Paul's use of the expression "In Christ" has been given in the previous section. I will now examine more closely its occurrence in one of the most important passages in the undisputed letters, namely Galatians 3.26-29:

"For in Christ Jesus you are all children of God through faith. As many of you as were baptized into Christ have clothed yourselves with Christ. There is no longer Jew or Greek, there is no longer slave or free, there is no longer male and female; for all of you are one in Christ Jesus. And

if you belong to Christ, then you are Abraham's offspring, heirs according not the promise".[8]

As we have seen, Paul has regularly used the term "in Christ" to refer to the situation of all believers (Gal 1.22). Following his concern to show his own position in relation to the acceptance of Gentiles (the likely identity of his addressees) in Gal 2.8-14, Paul then turns to the message which now must be conveyed with some urgency to the Galatians communities namely, that, through faith in Jesus Christ, every person is justified (2.16).

[8] [26] πάντες γὰρ υἱοὶ θεοῦ ἐστε διὰ τῆς πίστεως ἐν Χριστῷ Ἰησοῦ. [27] ὅσοι γὰρ εἰς Χριστὸν ἐβαπτίσθητε, Χριστὸν ἐνεδύσασθε· [28] οὐκ ἔνι Ἰουδαῖος οὐδὲ Ἕλλην, οὐκ ἔνι δοῦλος οὐδὲ ἐλεύθερος, οὐκ ἔνι ἄρσεν καὶ θῆλυ· πάντες γὰρ ὑμεῖς εἷς ἐστε ἐν Χριστῷ Ἰησοῦ. [29] εἰ δὲ ὑμεῖς Χριστοῦ, ἄρα τοῦ Ἀβραὰμ σπέρμα ἐστέ, κατ' ἐπαγγελίαν κληρονόμοι.

Paul writes with passion on account of what has occurred earlier. In Paul's absence, new arrivals ('agitators' 1.7) have come, seeking to impose the Judaic law, most particularly, the law concerning circumcision, on the community. Paul responds vehemently, citing his apostolic authority (1.1) and condemning what he sees as a perversion of the gospel. Paul proclaims that the source of his gospel is divine since he received it directly "through a revelation from Jesus Christ" (1.12). As a result, he is able to say with certainty, "through the law I died to the law, so that I might live to God. I have been crucified with Christ and it is no longer I who live but Christ who lives in me" (2.19-20).

Paul's reflection in the passage leading up to Gal 3.26-29 seems to present two polarising realities: the first refers to the time "before faith came" - Πρὸ τοῦ δὲ ἐλθεῖν τὴν πίστιν (3.23) the second is clearly, "after faith came" - ἐλθούσης δὲ τῆς πίστεως (3.25). The first reality is

dominated by the law. Paul sees this as a necessary stage, when the law acted as a disciplinarian - παιδαγωγὸς (3.24), likened to the slave in a Roman household who supervised a young child.[9] In the same way, the Law was Israel's disciplinarian[10] until the coming of a second and greater reality in the person of Jesus Christ. Through him has come justification by faith. The discipline of the law must give way "so that what was promised through faith in Jesus Christ might be given to those who believe" (3.22).

In verse 3.26 the expression "in Christ" opens Paul's declaration to the Galatians, that "you are all children of God through faith". Paul points to the new status of those who believe in Christ Jesus. Christ is both the cause and agent of this change. It is even more emphasised by the word γὰρ – 'because' or 'for'. The

[9] C. R. Hume. *Reading Through Galatians* 62.
[10] Ibidem 61-62.

verb, εστε here is plural indicating that, through Jesus, believers are incorporated into the family of God – they can call God 'Father'. This comes about "through faith" because "no one is justified before God by the law" (Gal 3.11). Believers through their faith, follow the example of Abraham who believed in the Lord; and "the Lord reckoned it to him as righteousness" (Gen 15.6, Gal 3.6). Now they are sons, not children who need a guardian but mature people, led by faith, as pointed out, rightly, by Tom Wright.[11] The NRSV translation of the word υἱοί as *children* is unfortunate because, might be said to weaken the impact of Paul's words.

In verse 27, the conjunction γὰρ appears again, although here it is not translated. Paul repeats the word to emphasise a succession of consequences following the coming of faith (3.25) and to make this

[11] Tom Wright. *Paul for everyone. Galatians and Thessalonians* 40.

message clear, especially for those who doubt or have been misled (3.1). The word ἐβαπτιζω, 'to be baptised' means to be immersed in water, to be purified in a religious context.[12] Gaventa speaks of Christians being thus, "located in the sphere of Jesus Christ".[13] This conveys perhaps the sense of believers standing alongside Christ. Yet here Paul uses the preposition εις 'into' rather than the usual ἐν Χριστῷ. A deeper sense of entering into Christ seems intended.

This is the only mention of Baptism in the letter to the Galatians and it anticipates Paul's treatment of it in Romans 6.3-4. In Galatians, Paul writes of believers "being clothed" with Christ in baptism (3.27), suggesting perhaps a new self, transformed in Baptism by God in Christ. The word 'ἐνεδύσασθε' literally means 'being clothed'.[14] For Hang Hongze this

[12] John Bligh. *Galatians A Discussion of St. Paul's Epistle* 324.
[13] Gaventa 1380.

suggests the incorporation of "people's identities"[15] into Christ so that their conduct "manifests the glory of Jesus Christ".[16] John Calvin interprets the phrase, "clothed with Christ" as a metaphor which "means that they are so closely united to him, that, in the presence of God, they bear the name and character of Christ, and are viewed in him rather than in themselves".[17]

Paul points to the consequences of baptism, of believers collectively being 'clothed with Christ' as he shows the transformation which must necessarily take place in the community of believers (3.27). The apostle stresses the life of faith

[14] Jung Hoon Kim. *The Significance of Clothing Imagery in the Pauline Corpus* 10.

[15] Hang Hongze. *An apercu of Paul's Letter to Galatians* 58.

[16] Ibidem.

[17] Calvin's commentaries. "Galatians 3" <http://biblehub.com/commentaries/calvin/galatians/3.htm>. Accessed on 05.10.2017.

which begins with the Christ event and three times stresses that earlier divisions no longer apply: οὐκ ἔνι - "there is no longer". Triple use of this expression indicates that there is no way back to the previous existence. The new reality of living 'in Christ' calls for the breaking down of all social divisions. Here is a new radical vision of a society in which the barriers of class, gender and religion are to be set aside. In the Christian community, Jews and Gentiles, slaves and masters, men and women are to see their lives bound together in ways never realised before and to discover the new unity which has become possible through Christ and indeed resides in him.

Gal 3.27 may be a part of ancient baptismal formula, as Matera suggests[18] or perhaps here is an early Christian slogan repeated in communities formed of people from different social and religious

[18] Frank Matera. *Galatians.* 146.

backgrounds. Gaventa[19] is clear that for Paul the source of all unity, always, is Christ himself. Paul says: "for all of you are one in Christ Jesus". Here, the Apostle unveils to the believers "the essence of Christian proclamation".[20] Christians are one in Jesus Christ, who is one, because God is one.

Paul follows his declaration of believers' unity in Christ by referring to their 'belonging' to Christ (3.29). He uses the conjunction εἰ - 'if' (3.29) - as a marker of the condition under which believers can claim to be Abraham's children. Paul has stressed that it is faith which makes believers members of God's family and now emphasises that in belonging to Christ, through faith, believers can claim to be the offspring of Abraham, the one made righteous through faith (3.6).

[19] Gaventa 1380.
[20] Richard N. Longenecker. *Galatians* 159.

Abraham himself believed (3.29) and received the promise – ἐπαγγελίαν. The word κληρονόμοι – means literally heirs. Being heirs, believers participate through faith in the promise given to Abraham, the promise of an offspring - Christ. As Luhrmann notes, here Paul is confirming that all Gentiles and Jews who believe in Christ become the heirs of Abraham's promise.[21]

Thus this whole passage, Galatians 3.23-29 stresses very clearly the importance, for the individual and for the Christian community, of belonging to Christ. The faith of those who are baptised is a gift which makes them Abraham's heirs. Their transformation through Baptism means a new way of life for all, since all are children of God through Christ. Everything draws towards Christ as a climax. To be "in Christ", for Paul, then, describes the

[21] Dieter Luhrmann. *Galatians. A Continental Commentary* 78,81.

goal and centre of the Christian life on earth.

Section 3

"In Christ" as a mystical experience, as incorporation.

Having considered Paul's language in the undisputed letters and more particularly in Galatians 3.26-29, I have chosen to examine the term 'in Christ' more closely, in relation to its various scholarly interpretations, in order to consider its most accurate meaning in the Galatians passage. Examination of this term "in Christ", has become a prominent theme in biblical studies,[22] with scholars taking up particular positions. Two have been especially evident. This new existence "in

[22] Dunn 391.

Christ" has been described by some scholars as *participation,* by others as *incorporation.*[23] The idea of 'incorporation' points to a mystical understanding of the term; whereas 'participation' has prompted an ecclesial interpretation. Justification for both arguments emerges from the passage in Galatians 3:26-29. First I will present the former approach and then discuss the latter.

Adolf Deissmann's was an early view which emphasised the interpretation of "in Christ" as a mystical reality. In his study of 1892 Deissmann described it as expressing "Christ-intimacy".[24] Deissmann based his view largely on Galatians 2.20 and 3.27: "I have been crucified with Christ and I no longer live, but Christ lives in me. The life I now live in the body, I live by faith in the Son of God, who loved me and gave himself for me"; and its link with

[23] Elliott C. Maloney. *Saint Paul Master of Spiritual Life "in Christ"* 116.

[24] Adolf Deissmann in Campbell 32.

3.27: "As many of you as were baptized into Christ have clothed yourselves with Christ".

Deissmann rejected the Hellenistic mystical idea of being so united with deity as to become one.[25] He regarded mysticism as "any religious tendency that connects to God 'through inner experience without the meditation of reasoning'".[26] For Deissmann, Paul's believing in Christ meant that he shared the faith of Christ; he belonged to Christ, and was thus 'incorporated' into him. For Paul nothing existed outside the reality of Christ. The fellowship – κοινωνία that Paul shared with Christ was a perfect fulfilment, a "glowing fire"[27] of the Divine who "is anchoring many souls into the Soul of the One".[28]

[25] Ibidem.
[26] Deissmannn in Campbell 32.
[27] Adolf Deissmann. *St. Paul: A study in Social and religious History* 134.
[28] Ibidem 232.

Forty years later, Albert Schweitzer, in 1930, took up the same idea, declaring that: "Christ's mysticism is the centre of Paul's thought".[29] However, he saw this mysticism as an intermediate state, preceding the full, eschatological realisation of God's mysticism.[30] Paul, Schweitzer maintains,[31] was urging Christians to live a good life in closeness to Christ so that they might subsequently achieve an eschatological mystical union with God. Moreover, in experiencing the mystical life with Christ, they encounter the supernatural which will one day be manifested in them.[32]

In opposition to the "protestant" understanding of Deissmann and Schweitzer, Alfred Wikenhauser (1960) pointed out that it is not faith that causes

[29] Albert Schweitzer. *The Mysticism of Paul the Apostle* 22.
[30] Campbell 36.
[31] Ibidem 38.
[32] Schweitzer 110.

the mystical union of believers with Christ, but baptism, which brings a person into a relationship with the Divine One.[33] Yet "without faith, there is no union with Christ. Faith is a precondition of union".[34] This faith rests on belief in the resurrection of Christ. "Only one who has attained this faith can enter upon a mystical relationship with Christ".[35] However Wikenhauser also points to other instances in which the term, "in Christ" does not convey a mystical union but rather shows Christ as agent of the Father's redemptive action,[36] for example, where Paul writes, "in Christ God was reconciling the world to himself" (2Cor 5.19).

Gert Pelser (1998) continues to pursue the idea of a mystical union, suggesting that

[33] Alfred Wikenhauser. *Pauline Mysticism: Christ in the Mystical Teaching of St. Paul* 123.
[34] Cambell 43.
[35] Wikenhauser 129.
[36] Ibidem 24.

the phrase, "in Christ" is about "a totally new form of existence… one fully controlled by Christ. Here is a new personality in which Christ can be identified, and, at the same time, the believer retains her/his identity. It is a union between Christ and the believer… that can probably be best described as 'mystical'".[37]

[37] Gert M. M. Pelser. "Could the 'formulas' *dying and rising with Christ* be expressions of Pauline mysticism"? 132.

Section 4

"In Christ" as an ecclesiastical reality, as participation.

A number of scholars rejected any idea of a mystical union in Paul's use of "in Christ", emphasising instead its ecclesial implications and its message of 'participation'.

Rudolf Bultmann (1953), in opposition to Schweitzer, maintained that the "in Christ" formula did not express any mystical reality. Instead Paul used this expression, to point to believers' participation in the community of Christ, that is, in the "Body of Christ" (1Cor 12.27). For Bultmann the whole of Galatians 26-29 encompassed what he described as: "the state of being articulated into the 'body of Christ' by baptism".[38] The whole idea of "in Christ',

therefore, signifies for believers their belonging to the church. Michel Bouttier (1962) went even further, coming to the conclusion that Paul's statement could be understood only in the light of the eschatological fulfilment of the Kingdom of God. Through baptism individuals entered the community of the church and in so doing, entered into the mystery of Christ, the crucified and risen Lord, and so could look forward to their future union with him beyond death".[39]

C. F. D. Moule (1977) also favoured an ecclesial interpretation.[40] "If it is really true that Paul thought of himself and other Christians as 'included' or 'located' in Christ; ... it indicates a more than individualistic conception of the person of Christ".[41] For Paul, participation in the life

[38] Rudolf Bultmann. *Theology of the New Testament* 311.
[39] Campbell 45.
[40] C.F.D. Moule. *The Origin of Christology* 62.
[41] Ibidem.

of Christ was a natural consequence of baptism. Gal 3.27-28 refers to the unity of all who believe and are baptized in Christ. This unity comes about through participation in the Body of Christ.[42]

Such an understanding also characterized Karl Barth's (1968) Christological reflections. He viewed the union between Christ and believers as indicating the spiritual presence of Christ in the church. Moreover, Paul's use of the Greek εν –'in' "indicates that Christ is spatially present where Christians are, and that Christians are spatially present where Christ is, and not merely alongside, but in exactly the same spot".[43] Barth described the whole of humanity as being "in Christ". For him, by its nature, humankind exists in Christ as its existential end.[44]

[42] Ibidem 65.
[43] Campbell 47.
[44] Ibidem 46.

More recently, James D. G. Dunn (2003)[49] insists that Paul's emphasis is on the community members as sharers in Christ. They share in his death (2Cor 7.3) and in his life (Rom 6.8), in his title of 'heir' (Gal 3.29), and even in his mind (Phil 2.5). "We simply need to underline the tremendous sense of 'togetherness' implicit in Paul's language".[45] Nonetheless Dunn does not entirely reject the mystical aspect of "in Christ", recognising its possibility, and commenting that in Paul's expressions "there are depths and resonances... which we may not be able fully to explore, but for which we need to keep our ears attuned".[46]

[45] Dunn 404.
[46] Ibidem.

Section 5

Reflection on the mystical and ecclesiastical approaches.

These two interpretations of "in Christ" unveil crucial elements of Christian doctrine. Each position in its way rediscovers the richness of the Word of God. Each of them also tries to understand Paul, his intentions, and the message being conveyed in this phrase.

I believe that Paul's encounter with the Risen Christ on the way to Damascus was profoundly transforming. It was a real event, a fact, which Paul describes clearly in Galatians 1.11-17), from which he began to perceive the world and humankind from a whole new standpoint.

I myself cannot approach the term "in Christ" without taking a personal view. When I hold Paul's Letters in my hands, I

read the Word of God. I read also the story of Abraham, who "believed God and it was reckoned to him as righteousness" (Gen 15.6; Gal 3.6). Here and in Romans 4.1-12, I note that Paul is at pains to show Abraham's faith and God's promise. This promise preceded the coming of Christ and at the same time anticipated it and the union between humanity and Christ which then became possible. For Paul the spiritual union with Christ is real to such an extent, that Paul is able to say: "it is no longer I who live, but it is Christ who lives in me" (Gal 2.29).

I cannot fully embrace Deissmann's idea of mysticism in Paul's expression "in Christ". It seems to be detached from Paul's reality, the choices and struggles of daily life in the community. Besides, in Deissmann's understanding the mystical union implies certain passivity on the part of the individual, which is not implied in Gal 3.26-9. More in tune with Paul is Wikenhauser's definition of mysticism:

"that form of spirituality which strives after (or experiences) an immediate contact (or union) of soul with God".[47] This definition suggests that Christ and the community of believers exist in a relationship of divine grace, which seems to meet Paul's declaration in Gal 3.26 "for in Christ Jesus you are all sons of God".

Bultmann's emphasis, solely on the ecclesial aspect of "in Christ", which reflects his own profound sense of the community's sharing with Christ in his suffering and death (Gal 2.20), and in his risen life (1Cor 15.20-27), is more attractive to me than Karl Barth's contention of "Christ being spatially present where Christians are, in the same spot".[48] Paul speaks about Christ being spatially present amongst the faithful, but in the future, during his second coming. Furthermore, Barth's idea of all humankind

[47] Wikenhauser 14.
[48] Campbell 47.

existing "in Christ" by definition[49] would seem to deny that Baptism is necessary for salvation.[50]

Nevertheless, I share with Barth, as far as I understand his thought, a belief, that we are "in Christ" as individuals and as a community of the faithful. As Dunn points out,[51] this relationship is ordered by God to be personal and intimate; mystical and ecclesial; temporal and eternal, here and now imperfect and perfected in eschatological reality; including individuals, the Church and the whole creation.

Galatians 3.27 says: "As many of you as were baptized into Christ". To me this seems to reflect both individual and mystical incorporation, and at the same time ecclesial participation. The text is about the group of individuals who chose

[49] Ibidem 46.
[50] CCC 1257.
[51] Dunn 403-404.

to embrace Christ as their Lord in their baptism. For me, there is no other way of understanding "in Christ" than by recognising how two meanings converge here, the mystical and the ecclesial. These two cannot be separated, because at every stage Paul is conscious of both meanings and conveys them in a number of ways, especially in Galatians 3.26-29.

Moreover, Paul urges Galatians to recognise that "neither circumcision nor uncircumcision is anything but a new creation is everything" (6.15). They themselves are Christ's 'new creation", for in Baptism they became 'clothed ... with Christ' (3.27). Individually they can experience a mystical union with Christ which changes their lives completely. At the same time this is a shared union with all who believe in Christ, the whole εκκλησια - 'assembly' is "in Christ". Here believers participate in Christ's risen life and belong to God through Christ.

I am convinced that Paul embraced both meanings in his use of the term, "in Christ". As a pious Jew, he doubtless recited the *Shema*[52] many times a day, the prayer which calls Israel to a deep and intimate relationship with the invisible God. It is a command not only to the nation as a whole, but also to each individual. The corporate and individual nature of the Jews' covenant with God, who himself invited them to become his people was now being offered to all believers and through Christ was made possible to all.

[52] Sara E. Karesh, Mitchell M. Hurvitz. *Encyclopedia of Judaism* 471.

Conclusion.

In this essay I have examined the expression ἐν Χριστῷ in the seven undisputed letters of Paul and focused particularly on Gal 3.26-29, which for me most fittingly expresses the meaning of that phrase. The various interpretations of ἐν Χριστῷ, developed in the years since Deissmann's work (1912) have been examined for their relevance to this study, particularly the arguments for: "participation" or "incorporation". I have concluded that both are relevant and provide important insights into Paul's meaning in Gal 3.26-29.

"For 'in him we live and move and have our being'; ... 'For we too are his offspring".[53] This verse from Acts of the

Apostles fits very well with the topic of my investigation in this paper. Jesus Christ, the Lord, gives life, capability to move and existence to all of us. Paul knew and experienced that reality which, though spiritual, is tangible. His use of "in Christ" – ἐν Χριστῷ touches many aspects of the Christian's life with God. Sometimes Paul speaks about his own relationship with Jesus e.g.: "The life I now live in the flesh I live by faith in the Son of God".[54] Often he points out the work of God done through Christ, e.g.: "the free gift of God is eternal life in Christ Jesus our Lord".[55] The Apostle applies this term to explain a new state of those who believed in Christ, for instance in the analysed passage from Galatians: "for in Christ Jesus you are all Children of God through faith".[56]

[53] Acts 17.28.
[54] Gal 3.20.
[55] Rom 6.23.
[56] Gal 3.26.

Paul's expression "in Christ" in Galatians 3:26-29 conveys a broad message, which can be understood with various emphases. It can be interpreted as mystical incorporation, as per Deissmann, Schweitzer, Pelser, or Wikenhauser. It can be explained in ecclesial terms, describing the idea of participation, suggested by Bultmann and Dunn. However, it also can be understood in both terms together, which I myself outlined in the last section.

Personally, I am convinced that Paul, using the term "in Christ", touched on mystical and ecclesial, temporal and eschatological realities. He could not do otherwise, since he himself made his life as a service to Christ. He was convinced that no power, or person, or event was able to break his intimate relationship with Christ.[57] Paul of Tarsus saw all who are baptised as one Body in Christ.[58] He

[57] Rom 8.35-39.
[58] Rom 12.5.

regarded himself and others as members and heirs of God's family.[59] In this spiritual family, all are united in the One Lord as community. Each of the members, created in the image of God, have a close unifying relationship with the Lord, in the image of the relationship between the Son and the Father.

[59] Gal 3.26,29; 4.7.

Bibliography:

The Holy Bible. NRSV. Oxford: University Press, 1995.

Bligh, John. *Galatians A Discussion of St. Paul's Epistle*. London: St. Paul's Publication, 1970.

Bultmann, Rudolf. *Theology of the New Testament*. Translated by Kendrick Grobel. London: SCM, 1952.

Campbell, Constantine R. *Paul and Union with Christ. An Exegetical and Theological Study*. Michigan: Zondervan, 2012.

Deissmann, Adolf. *St. Paul: A study in Social and religious History*. Translated by Lionel R. M. Strachan. London: Hodder and Stoughton, 1912.

Dunn, James D. G. *The Theology of Paul the Apostle*. Second edition. London: T&T Clark, Eerdmans Publishing, 2003.

Gaventa, Beverly. "Galatians" in *Eerdmans Commentary on the Bible*. ed. Dunn, James D. G. Cambridge: William B. Eerdmans Publishing Company, 2003.

Hongze, Hang. *An apercu of Paul's Letter to Galatians*. Translated by Roger Noether. Bloomington, Indiana: Author House: 2011.

Hooker, Morna. "Galatians". in *The Cambridge*

Companion to St Paul, James D. G. Dunn (ed.). Cambridge: University Press, 2003.

Hume, C. R. *Reading through Galatians*. London: SCM, 1997.

Karesh, Sara E. Hurvitz, Mitchell M. *Encyclopaedia of Judaism.* In Series *Encyclopaedia of World Religions* (ed.) J. Gordon Melton. New York: Facts On File, 2006.

Kim, Jung Hoon. *The Significance of Clothing Imagery in the Pauline Corpus*. London: T&T Clark International, 2004.

Maloney, Elliott C. *Saint Paul Master of Spiritual Life "in Christ"*. Collegeville, Minnesota: Liturgical Press, 2014.

Matera, Frank J. *Galatians.* Sacra Pagina 9. Collegeville, Minnesota: Michael Glazier 1992.

Moule, C.F.D. *The Origin of Christology*. Cambridge: University Press, 1977.

Longenecker, Richard N. *Galatians*. Word Biblical Commentary. vol 41. eds. B. Metzger, D. Hubbard, Glenn Barker, John Watts, Ralph Martin, James Watts, Lynn Allan Losie. Dallas: Word Books Publisher 1990.

Luhrmann, Dieter. *Galatians. A Continental Commentary*. Translated by C. Dean Jr. Minneapolis: Fortress Press, 1992.

Pelser, Gert M. M. "Could the 'formulas' *dying and rising with Christ* be expressions of

Pauline mysticism"? in *eotestamentica* 32 (1) 1998 115-134.

_____ "Christ" in *Dictionary of Paul and his Letters*. ed. Gerald F. Hawthorne, Ralph P. Martin. Leicester: Intervarsity Press, 1993.

Schweitzer, Albert. *The Mysticism of Paul the Apostle.* New York: Henry Holt, 1931.

Wikenhauser, Albert. *Pauline Mysticism: Christ in the Mystical Teaching of St. Paul*. Translated by Joseph Cunnigham. Freiburg: Herder and Herder, 1960.

Witherington III, B. *The Letters to Philemon, the Colsossians and to Ephesians. A Socio-rhetorical Commentary on the*

Captivity Epistles. Cambridge: William B. Eerdmanss, 2007.

Websites:

Bible Hub. http://biblehub.com/greek/907.htm. Accessed on 11.10.2017.

Bible Study Tools http://www.biblestudytools.com/lexicons/greek/nas/baptizo.html.

Accessed on 05.10.2017.

Calvin's commentaries. "Galatians 3"

http://biblehub.com/commentaries/calvin/galatians/3.htm. Accessed on 05.10.2017.

Catechism of the Catholic Church.

http://www.vatican.va/archive/ccc_ccs/archive/catechism/p2s1c1a2.htm. Accessed on 27.10.2017.

Greek Lexicon, http://www.greekbible.com/l.php?koinwni/an-----nsf-_. Accessed on 25.08.2017.

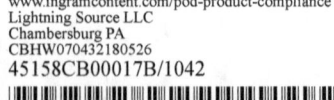

www.ingramcontent.com/pod-product-compliance
Lightning Source LLC
Chambersburg PA
CBHW070432180526
45158CB00017B/1042